Texas

What's So Great About This State?

There is a lot to see and celebrate...just take a look!

CONTENTS

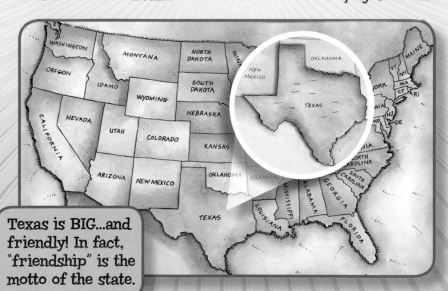

Texas is BIG...and friendly! In fact, "friendship" is the motto of the state.

Well, how about...
the land!

From the Mountains...

Texas is one big state! In fact, it's second only to Alaska in size. There are many different habitats throughout the state including wind-swept mountains, colorful deserts, rolling hills, pine forests, beaches, and more. But the state is divided into four main regions: the Mountains and Basins, the Great Plains, the North Central Plains, and the Coastal Plains.

The land in the northern Panhandle rises more than 4,000 feet above sea level. However, the highest spots in the state are in West Texas. Here, towering mountains are surrounded by arid desert.

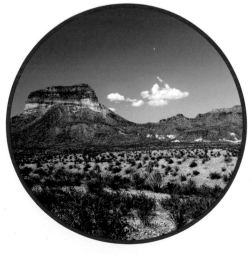

A view of the Chisos Mountains and desert basin in West Texas.

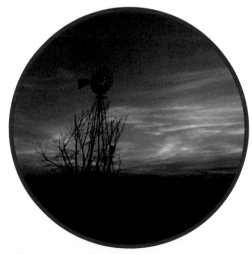

Sunset on the High Plains of Texas, part of the Great Plains.

...To the Gulf

The land gets lower as it slopes down to the Gulf of Mexico. Rolling hills and prairies give way to marshy wetlands. Sandy beaches and barrier islands line the coast. The Gulf of Mexico provides wildlife habitats and supports the fishing and tourism industries. But that's not all. Huge rigs off the coast drill beneath the Gulf's water to reach the valuable oil and gas supplies that are stored there.

It's quite an adventure to explore the land across Texas. Take a closer look at the next few pages to see just some of the interesting places you can visit!

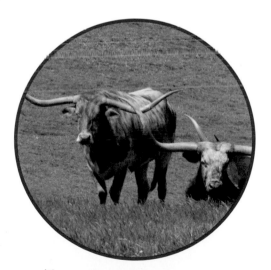

It's no surprise to see Longhorn cattle in the fields around Dallas.

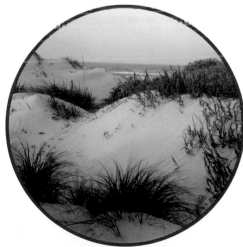

Sand dunes on Padre Island protect the inland from the Gulf of Mexico.

A field of Texas bluebonnet flowers

Mountains and Basins

MOUNTAINS AND BASINS

El Capitan at sunrise in Guadalupe
Mountains National Park

The Mountains and Basins region is in the western corner of Texas. It's a place of unusual beauty. The state's highest mountains are here. In between are low areas of bone-dry desert basin.

What's so special about this region?

If you want to explore the towering mountains of West Texas, you better bring your hiking boots! Guadalupe Mountains National Park has more than 80 miles of hiking trails.

And if you like fossil hunting, the rocky landscape is loaded with them. Believe it or not, the Guadalupe Mountains were once a living, growing reef under the waters of an ancient (and long gone) sea.

...and there's more!

Farther south is Big Bend National Park. At more than 1,200 square miles, this park is about the same size as the state of Rhode Island! The whole Chisos Mountain range is contained within the park.

So where's the desert basin?

The Chihuahuan Desert surrounds the mountains in West Texas and stretches south for hundreds of miles into Mexico. Even though the desert doesn't get much rain, plenty of plants and animals have adapted to survive there.

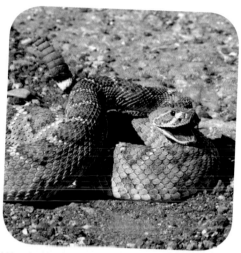

Watch out! Rattlesnakes don't mind desert conditions.

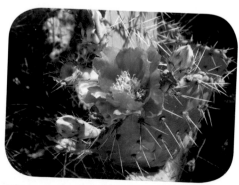

After a rare rain, a desert cactus blooms.

The Plains

NORTH CENTRAL PLAINS

GREAT PLAINS

COASTAL PLAINS

Fields of wildflowers are common
in the Central Plains of Texas.

The rest of Texas is classified into several regions of plains. There are the Great Plains, the North Central Plains, and the Coastal Plains—but there's nothing "plain" about these places!

What's so great about the Great Plains region?

Well, for one thing, this region of Texas is part of the larger Great Plains region of North America that stretches all the way into Canada!

In Texas, the Great Plains includes a lot of different land. The canyons of the High Plains and the grazing lands of the Edwards Plateau are part of this region. (Texas is known for raising cattle, sheep, and goats, you know!) This region also includes the beautiful rolling hills and winding rivers of the Llano Basin and, to the south, the Hill Country.

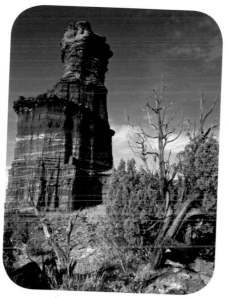

The Lighthouse Rock formation is part of the Great Plains region in Palo Duro Canyon State Park.

What about the North Central Plains?

Again, the land throughout this region can be quite varied. Flat prairie and rolling plains can stretch for miles. But large numbers of hardwood trees grow in the Cross Timbers areas.

...and don't forget the biggest region of all!

The Coastal Plains includes most of eastern and southern Texas. Tall trees of the Piney Woods and rich soils of the Central Texas prairies are in this region. So are marshy lowlands and sandy island beaches along the Gulf of Mexico.

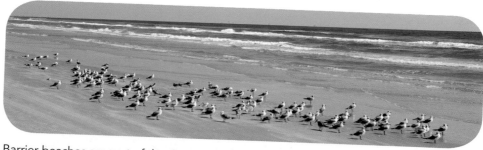

Barrier beaches are part of the Coastal Plains region on Padre Island.

Rivers and Lakes

The San Antonio River Walk celebrates
the beauty of the river.

Texas has thousands of freshwater lakes—most of them human-made. And thousands of miles of rivers flow through the state. The largest river is the Rio Grande—which means "big river" in Spanish. It forms part of the border between the United States and Mexico. Most major rivers, including the Rio Grande, Nueces, Brazos, Colorado, and Trinity rivers empty into the Gulf of Mexico.

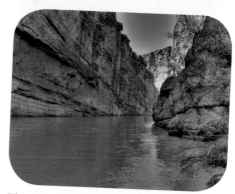

The Rio Grande flows through the Santa Elena Canyon in Big Bend National Park.

Why are the rivers and lakes so special?

Lakes and rivers provide recreation, transportation, food, and habitats! Some of the water in lakes and rivers can be used to make electric power and to water crops. However, most importantly, water is needed for drinking. Residents depend on lakes, rivers, and aquifers to supply enough water to quench a Texas-size thirst.

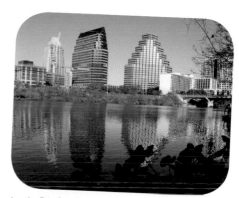

Lady Bird Lake is in the capital city of Austin.

Wait...what's an aquifer?

Underneath a large portion of Texas' soil is a layer of limestone, a soft rock that absorbs rainfall like a sponge. This layer allows an underground lake, or aquifer, to form. Water from an aquifer can bubble to the surface as a freshwater spring, but it can also be pumped out. The Edwards and the Ogallala aquifers are major sources of water for millions of people in Texas.

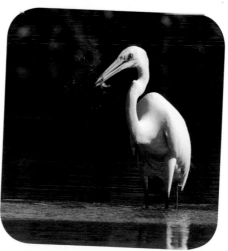

People aren't the only ones who fish! An egret catches a meal in the Armand Bayou near Pasadena.

Well, how about...
the history!

Tell Me a Story!

The story of Texas began thousands of years ago. Following the tradition of their ancestors who first lived on the land, Native Americans made their homes throughout the state. Most lived in groups called tribes, and each had its own culture. Descendants from many tribes, such as the Caddo, Comanche, and Tigua, still live throughout the state today.

You often hear people speak of these Native American tribes because many places throughout the state are named after them. Cherokee and Nacogdoches counties, Comanche City, and Caddo Lake State Park—these names all honor the groups of people who first lived on the Lone Star State land so long ago.

This statue in Fort Worth honors the last chief of the Quahadi Comanches, Quanah Parker. Chief Parker provided leadership for over 25 years until his death in 1911.

...The Story Continues

Eventually, Texas became home to many other groups including Spanish and French explorers; Mexican, European, and American settlers; and African Americans. In the process, many battles were fought over who would control the land. Have you ever heard the phrase "Six Flags over Texas?" It refers to the fact that six flags have flown over Texas since the early 1500s.

But history isn't always about war. Texans have always been educators, inventors, painters, writers, singers, and builders. Many footprints are stamped into the soul of Texas' history. You can see evidence of this all over the Lone Star State!

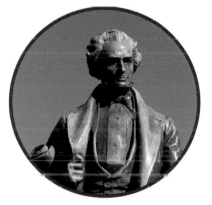

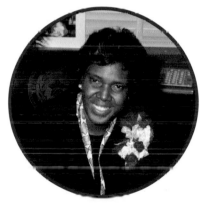

This statue of Stephen F. Austin (1793-1836) honors "the Father of Texas." When the Mexican government offered free land to people, Austin helped families move to southeastern Texas. By 1825, nearly 300 families were living in Austin's Texas colony. These settlers became known as the Old Three Hundred.

Barbara Jordan (1936-1996), was born in Houston. She was the first African American woman to serve in the Texas Senate and the first African American woman from a southern state to be elected to the United States House of Representatives.

Presidio La Bahia is an old
Spanish Fort in Goliad, Texas.

Monuments

Battleship Texas is a State Historic Site that is permanently anchored in the Buffalo Bayou at LaPorte, Texas. This famous battleship served in both World War I and World War II.

Monuments and historic sites honor special people or events. Battleship Texas is one of three sites in the 1,200-acre San Jacinto Battleground State Historic Site. The other two sites, a battleground and a memorial, honor the 1836 Battle of San Jacinto that brought Texas its independence.

Why are Texas monuments so special?

That's an easy one! There were many special people who helped build the Lone Star State. Some were famous soldiers and politicians. Others were just ordinary people who did "extraordinary" things to help shape both the state of Texas and the nation.

What kind of monuments can I see in Texas?

There are statues, plaques, murals, cornerstones, named streets—just about anything that reminds people of someone or something important will work. Almost every town in Texas has found some way to honor a historic person or event.

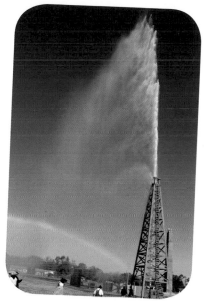

A 65-foot replica, or copy, of the Lucas Gusher in Beaumont celebrates the 1901 eruption on Spindletop Hill that changed the oil industry forever.

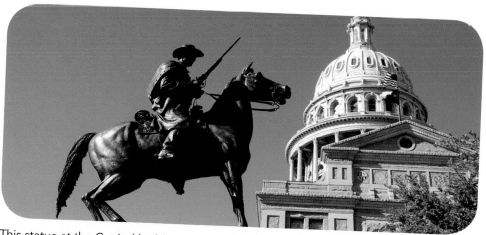

This statue at the Capitol building in Austin honors the Texas Rangers who first began protecting the people of Texas in 1823. Today, the men and women of the Texas Ranger law enforcement agency still wear boots, pistol belts, and white hats to honor the traditions of this elite group.

MUSEUMS

In the Blast Off Theater at the Houston Space Center, visitors feel the thrill of launching into space.

Museums don't just tell you about history—they actually show you artifacts from times past. Artifacts can be actual objects or models of objects—either way, they make history come alive.

Why are Texas' museums so special?

Texas museums include amazing exhibits with artifacts that tell the story of the state. The Institute of Texan Cultures in San Antonio contains 65,000 square feet of exhibits and displays that feature the unique stories of Texans.

What can I see in a museum?

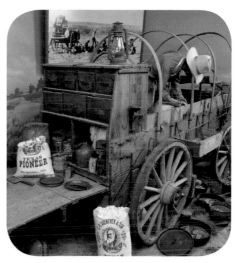

An easier question to answer might be, "What can't I see in a museum?" There are thousands of items exhibited in all kinds of different museums across the state. Do you want to know about cowgirls? The National Cowgirl Museum and Hall of Fame in Fort Worth honors women of the American West. Or perhaps you are interested in Hispanic art and music? In 1996, the Texas state legislature named The Museo Alameda in San Antonio the official State Latino Museum.

See how food was prepared on the open plains at the chuck wagon exhibit in the Panhandle-Plains Historical Museum in Canyon, Texas.

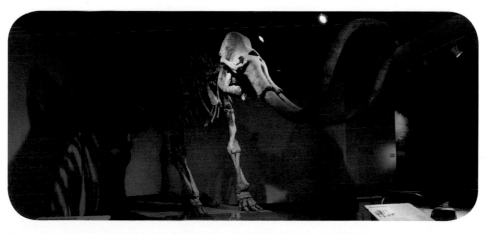

You can see a model of a woolly mammoth at the Museum of Nature and Science in Dallas.

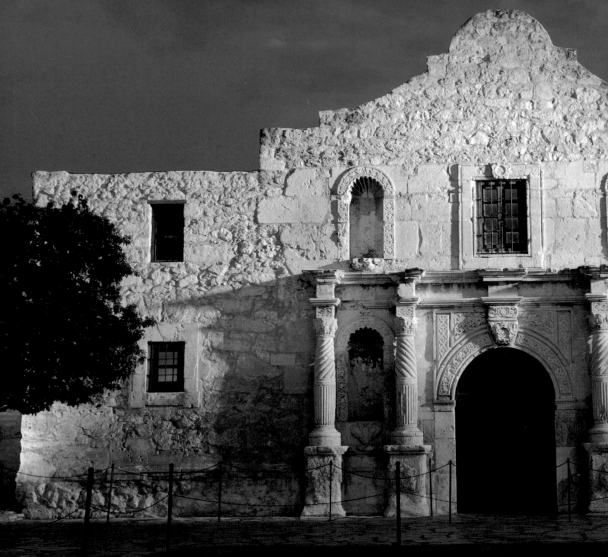

MISSIONS

Mission San Antonio de Valero was established in 1718 along the San Antonio River. However, at the start of the next century, it was renamed the Alamo.

In 1836, the Alamo mission-turned-fortress gained fame when an outnumbered group of Texian and Tejas people fought for thirteen days against Mexican General Santa Anna's troops.

So Who Won?

General Santa Anna's troops won. But the Alamo battle was a key event in the Texas Revolution. Eventually, Texas became a Republic—and "Remember the Alamo!" became a popular rallying cry to remind Texans of the sacrifices made to secure their state's independence.

Why were missions built? (....and what is a mission, anyway?)

Back in the late 1600s, leaders in Spain wanted to grow their presence in Texas—mostly to keep France out! As a result, Spanish leaders supported Franciscan missionaries in their quest to establish settlements, or missions, throughout Texas. A mission often had a church, workshops, ranches, and fields. A mission also usually had a presidio, or fort, nearby where Spanish soldiers lived.

The Franciscan missionaries taught Native Americans about the Christian religion—and the Spanish culture. Spanish leaders hoped Native Americans would become loyal Spanish supporters.

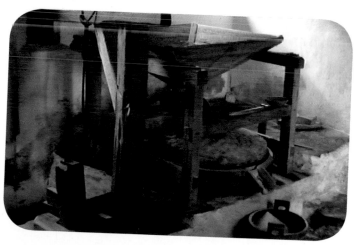

You can learn about life long ago at missions throughout Texas. A centuries-old gristmill still works at the Mission San José y San Miguel de Aguayo in San Antonio. Water power turns the large stone, which grinds grain into flour.

A Flawed Plan

Unfortunately, Native Americans weren't treated very well and many revolted. In the end, Spain lost control of Texas. But the missions and their villages had a lasting impact on Texas.

Well, how about...

the people!

Enjoying the Outdoors

More than 24 million people live in the Lone Star State. Though they have different beliefs and different traditions, Texans have plenty in common.

Most share a love of nature. Horseback riding, hiking, fishing, caving, and climbing—the list of things that Texans enjoy goes on and on! The many state and national parks are wonderful places to explore the great outdoors. Sand and surf can be found at the Padre Island National Seashore. Well-preserved dinosaur tracks are in Dinosaur Valley State Park. Since the natural environment is so important to Texans, most feel a shared responsibility to take care of it.

Sailing is popular at Galveston Bay.

Texans are great sports fans!

Sharing Traditions

In the towns and cities throughout the state, Texans share the freedom to celebrate different heritages. Have you ever been to a rodeo? Rodeos began as a way for cattle ranchers and cowboys to test their skills. Contestants compete in events like bull riding, calf roping, and barrel racing.

Cooking is another way to pass on traditions. Great Texan food recipes are cherished family keepsakes! Texas is known for its barbecue and chili. But the recipes served at Texas tables come from many different cultures. French, Cajun, Tex-Mex, African American, Polish—the list goes on. All contribute recipes for great food and fellowship!

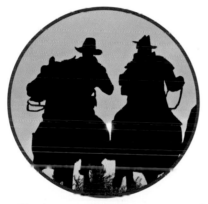

Cowboys on horses carry on the tradition of the Old West.

Chile con carne is a popular Tex-Mex food.

Enchanted Rock State Natural Area

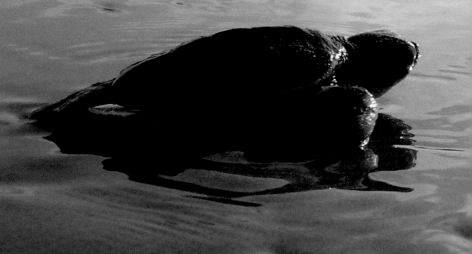

Protecting

A green sea turtle that hatched on Padre Island enters the Gulf of Mexico for the first time.

Protecting all of Texas' natural resources is a full-time job for many people!

Why is it important to protect the Lone Star State's natural resources?

The state of Texas is more than 700 miles wide, so that means there are a lot of different environments within its borders. Moving inland from the coast, the land changes from coastal marshes and low-lying wetlands to gently rolling hills. Forests and prairies give way to high plateaus, and, finally, mountains and deserts. All these different environments mean many different kinds of plants and animals can live throughout the state. In technical terms, Texas has great biodiversity! This biodiversity is important to protect because it keeps the environments balanced and healthy.

What kinds of organizations protect these resources?

It takes a lot of groups to cover it all. The U.S. Fish and Wildlife Service is a national organization. The Texas Parks and Wildlife Department is a state organization. The Texas Nature Tracker projects encourage citizen scientists to help monitor wildlife. They sponsor Watch Programs for a variety of animals—from black-tailed prairie dogs and horned lizards to hummingbirds and mussels.

And don't forget...

You can make a difference, too. It's called "environmental stewardship" and it means that you are willing to take personal responsibility to help protect the Lone Star State's natural resources. It's a smart choice for a great future!

Plants like this Texas sage grow at the Lady Bird Johnson Wildflower Center near the University of Texas at Austin.

A park ranger talks about desert plants in Big Bend National Park.

Creating Jobs

Texas Longhorns were the foundation for the cattle industry in Texas.

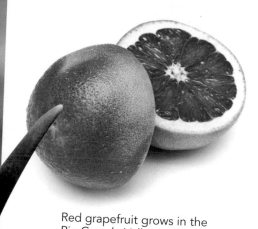

Red grapefruit grows in the Rio Grande Valley of Texas.

Texas does big business with what's above and below its land. Oil and natural gas pumped from beneath the Lone Star State provide many jobs. Aboveground, ranching and farming lead the way. A newer industry goes even higher. Wind turbines are now being used as a source of renewable energy.

Why is Texas a good place for business?

The land and the people make a good combination for a variety of businesses throughout the state.

What kinds of jobs are available throughout the state?

Texans have always been good at making things. Today many people work in the high-tech industry. Computer design, engineering, and research and development are just a few of the fast-growing segments.

Another big industry is the service industry. Millions of tourists travel throughout Texas each year. Many jobs are needed to help people sightsee, dine, and relax!

A high-tech industry needs computer technicians.

Don't forget the military!

The Air Force, Army, Navy, and the Coast Guard all have active facilities in the state. Whether training or working, the brave men and women who serve our country are held in great respect throughout Texas.

Military training is hard work!

Celebrating

The Texas Star Ferris Wheel at the State Fair of Texas is more than 212 feet tall.

The people of Texas really know how to have fun! The annual State Fair of Texas in Dallas is one of the largest in the country.

Why are Texas festivals and celebrations special?

Celebrations and festivals bring people together. From cooking contests to rodeos, events in every corner of the Lone Star State showcase all different kinds of people and talents.

What kind of celebrations and festivals are held in Texas?

Too many to count! But one thing is for sure, you can find a celebration or festival for just about anything you want to do. Do you like to eat strawberries? Poteet has held a Strawberry Festival for more than 60 years.

Mexican Americans celebrate their heritage at Cinco de Mayo festivals throughout Texas.

Want to hear some great music? Texas is known for Mexican mariachis, African American blues, Tejano, and country music. Try the Austin City Limits Music Festival.

Juneteenth, or Emancipation Day, is a state holiday in Texas. It celebrates the day (June 19, 1865) when the news finally reached Texas that enslaved African Americans were free.

Don't forget the seed-spitting contest!

Luling, Texas has a watermelon festival each year. At the "Watermelon Thump" there's a parade and live entertainment with popular melon-eating and seed-spitting contests!

It's fun to be a melon head at the Watermelon Thump!

Birds and Words

What do all the people of Texas have in common? These symbols represent the state's shared history and natural resources.

State Bird
Mockingbird

State Flower
Bluebonnet

State Tree
Pecan

State Fruit
Red grapefruit

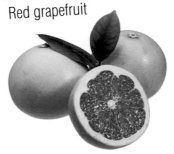

State Flag

State Reptile
Texas Horned Lizard

This animal is commonly called a horny toad but it's actually a lizard!

Toad= amphibian
Lizard= reptile

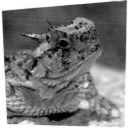

State Pepper
Jalapeño

Texas is one of the leading producers of jalapeño peppers!

State Small Mammal
Nine-banded armadillo

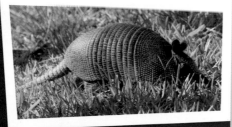

State Insect
Monarch Butterfly

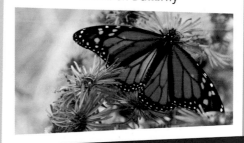

Want More?

Statehood—December 29, 1845
State Capital—Austin
State Nickname—Lone Star State
State Song—"Texas, Our Texas"
State Plant—Prickly pear cactus
State Large Mammal—Longhorn

State Vegetable—Sweet onion
State Shell—Lightning whelk
State Folk Dance—Square Dance
State Gem—Texas blue topaz
State Motto—"Friendship"

More Fun Facts

More

Here's some more interesting stuff about Texas.

Sun...or Snow?

Since it's such a big place, the weather in Texas can be quite different from one end to the other. Texans on the Gulf Coast can be playing at the beach while residents in the northern Panhandle are digging out from a snowstorm!

The Original Bat Cave

Austin goes a little batty every summer! That's when Mexican free-tailed bats return from their winter roost in Mexico. The bats' summer home is under the Congress Street Bridge.

Liquid Borders

A good portion of the Texas border is made of three rivers. The Rio Grande separates Texas and Mexico. The Sabine River separates Texas and Louisiana. The Red River separates Texas and Oklahoma.

The King of Ranches

One of the world's largest ranches, King Ranch, is located between **Corpus Christi** and **Brownsville**.

Border Town Fun

The "Grito"—or shout of joy—officially opens the Charro Days festival in **Brownsville** each year. This fiesta celebrates life on the border and shared culture with Mexico.

The Grand Canyon of Texas

At more than 20,000 acres, Palo Duro Canyon in the **Panhandle** of Texas is the second-largest canyon in the United States. Each year the Official Play of the State of Texas runs in the Pioneer Amphitheater located in this state park.

A Sweet-Smelling City!

The nation's largest rose garden is in **Tyler**. It is a 14-acre park with more than 38,000 rose bushes. Of course, it is also home to the Texas Rose Festival each year!

A Colorful Name

Amarillo, which means "yellow" in Spanish, is called the Yellow Rose of Texas. It's the largest city in the Panhandle.

Tragedy to Triumph

After President John F. Kennedy was assassinated in Dallas, native son Lyndon B. Johnson (born in **Stonewall**) served as the 36th President of the U.S. He was then elected by a wide margin in 1964 to serve another term.

What's Your Point?

A Texas Longhorn steer might grow trophy-sized horns extending over 9 feet, tip to tip.

Speeding Down the Tracks

During the 43-year period between 1836 and 1879, about 2,400 miles of railroad track were laid in Texas. In the following ten years more than 6,000 additional miles were constructed.

Stormy Weather

Lots of states in the U.S. get hit by tornadoes but Texas gets more than its fair share. It's part of Tornado Alley—a flat stretch of land from West Texas to North Dakota that is an ideal place for tornadoes to form.

The Six Flags of Texas

Under Spain:1519-1685; 1690-1821.
Under France:1685-1690
Under Mexico: 1821-1836
As a Republic: 1836-1845
In the Confederacy:1861-1865
As a U.S.state: 1845-1861; 1865-Present

Wild West Fashion

Paris has a replica of France's Eiffel Tower—topped with a red cowboy hat!

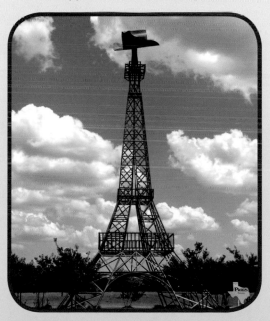

Round 'Em Up!

There is a daily cattle drive at the **Fort Worth** Stockyards' National Historic District.

A Friendly Name

Texas comes from the Caddo Indian word Tejas, which means "friends."

Find Out More

There are many great websites that can give you and your parents more information about all the great things that are going on in the state of Texas!

State Websites

The Official Website of the State of Texas
www.texasonline.com

Texas State Library and Archive Commission
www.tsl.state.tx.us

Texas Parks and Wildlife Department
www.tpwd.state.tx.us

Museums/Austin

The Bob Bullock Texas History Museum
www.thestoryoftexas.com

The Austin Museum of Art
www.amoa.org

Houston

The Houston Museum of Natural Science
www.hmns.org

The Children's Museum of Houston
www.cmhouston.org

Dallas

The Museum of Nature and Science
www.natureandscience.org

The African American Museum
www.aamdallas.org

San Antonio

The Alamo
www.thealamo.org

The Museo Alameda
www.thealameda.org

El Paso

El Paso Museum of History
www.elpasotexas.gov

Fort Worth

Fort Worth Museum of Science
www.fwmuseum.org

Aquariums and Zoos

Texas State Aquarium (Corpus Christi)
www.texasstateaquarium.org

Houston's Downtown Aquarium
www.aquariumrestaurants.com/downtownaquariumhouston

Dallas Zoo
www.dallaszoo.org

Gladys Porter Zoo (Brownsville)
www.gpz.org

Austin Zoo
www.austinzoo.org

Houston Zoo
www.houstonzoo.org

Texas: At A Glance

State Capital: Austin

Texas Borders: New Mexico, Oklahoma, Arkansas, Louisiana, Gulf of Mexico, Mexico

Population: Over 24 million

Highest Point: Guadalupe Peak is 8,749 feet above sea level

Lowest Point: Sea level at the Gulf of Mexico

Some Major Cities: Houston, Dallas, San Antonio, Austin, El Paso, Fort Worth

Some Famous Texans

George W. Bush (1946) raised in Midland; was the Governor of Texas and the 43rd President of the United States. His father George H. W. Bush was the 41st President.

Miriam A. "Ma" Ferguson (1875–1961) from Bell County; was the first female governor of Texas.

Selena Quintanilla-Pérez (1971–1995) from Lake Jackson; was a popular Hispanic singer that was revered by many in the Hispanic community.

Pattillo Higgins (1863–1955) from Sabine Pass; was a businessman who backed the plan that led to the greatest discovery of oil in Texas.

Sam Houston (1793–1863) was President of the Republic of Texas (twice), a U.S. Senator, and Governor of Texas.

Audie Murphy (1924–1971) from Kingston; was the most decorated U.S. combat soldier in World War II.

Sandra Day O'Connor (1930) from El Paso; is a lawyer and judge who became the first female member of the U.S. Supreme Court.

Cleto L. Rodriguez (1923–1990) from San Marcos; was a World War II veteran who received the Medal of Honor.

Joseph "Smokey Joe" Williams (1885–1951) from Seguin; was one of baseball's greatest pitchers.

Mildred "Babe" Didrikson Zaharias (1911–1956) from Port Arthur; was an Olympic athlete and the leading woman golfer of her time.

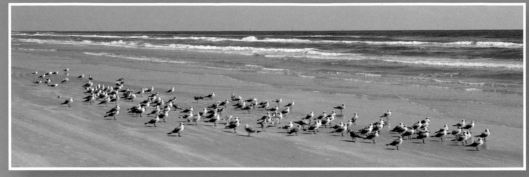
Birds comb the beach for food at Padre Island, Texas.

CREDITS

Series Concept and Development
Kate Boehm Jerome

Design
Steve Curtis Design, Inc. (www.SCDchicago.com); Roger Radke, Todd Nossek

Reviewers and Contributors
Stacey L. Klaman, writer and editor; Mary L. Heaton, copy editor; Eric Nyquist, researcher
Elizabeth Cruce Alvarez, editor, Texas Almanac (www.texasalmanac.com); Barbara Mitchell, Houston

Photography
Back Cover(a), 19b © Silvia Bogdanski/Shutterstock; Back Cover(b) © Yan Simkin/Shutterstock; Back Cover(c), 5a © Steve Byland/Shutterstock; Back Cover(d), 2-3, 26a © Robin Holden Sr./Shutterstock; Back Cover(e), 8-9 © NeonLight/Shutterstock; Cover(a), 2a, 27b © Rusty Dodson/Shutterstock; Cover(b), 27f © Marie C. Fields/Shutterstock; Cover(c), 16-17 © Natalia Bratslavsky/Shutterstock; Cover(d), 28 © Trudy Wilkerson/Shutterstock; Cover(e), 22-23 © Paula Cobleigh/Shutterstock; Cover(f), 9b, 13b © Ricardo Garza/ Shutterstock; 2b © Jim Parkin/Shutterstock; 3a © Douglas Knight/Shutterstock; 3b, 7a © Mike Norton/Shutterstock; 4-5 © Michael J. Thompson/Shutterstock; 5b © KALin1980/ Shutterstock; 6-7 © James Beach/Shutterstock; 7b, 32 © Philip Lange/Shutterstock; 9a © Jose Marines/Shutterstock; 9c, 18-19, 18a © Paul S. Wolf/Shutterstock; 10-11, 12-13 © VanHart/Shutterstock; 10a © 2008, William M. Windsor/RoundAmerica.com; 11a © Texas Historical Commission; 11b Courtesy of Texas State Library & Archives Commission; 13a Courtesy Spindletop-Gladys City Boomtown Museum; 14-15 © Space Center Houston; 15a Courtesy of the Panhandle-Plains Historical Museum; 15b Courtesy Museum of Nature & Science; 17a © Aldene Gordon; 18b © Mike Flippo/Shutterstock; 19a © Grant Terry/Shutterstock; 20-21 NPS Photo; 21a Carmen Sorvillo/Shutterstock; 21b NPS Photo; 23a © amlet/Shutterstock; 23b © Stephen Coburn/Shutterstock; 23c © John Wollwerth/Shutterstock; 24-25 © Chris Cornwell; 25a © James Steidl/Shutterstock; 25b Courtesy Mickie Bailey, watermelonthump.com; 26b Courtesy Keithimus/Wikipedia; 26c © Dominator/Shutterstock; 27a © Sergei Didyk/Shutterstock; 27c © Lori Skelton/Shutterstock; 27d © Carsten Reisinger/Shutterstock; 27e © Stephen Mcsweeny/Shutterstock; 29a © Filip Fuxa/Shutterstock; 29b © Lori Martin/Shutterstock; 31 © R. Gino Santa Maria/Shutterstock

Illustration
Back Cover, 1, 4, 6 © Jennifer Thermes/Photodisc/Getty Images

ISBN 978-1-58973-012-0
Library of Congress Catalog Card Number: 2009943360

1 2 3 4 5 6 WPC 15 14 13 12 11 10

Published by Arcadia Publishing
Charleston SC, Chicago IL, Portsmouth NH, San Francisco CA

For all general information contact Arcadia Publishing at:
Telephone 843-853-2070
Fax 843-853-0044
Email sales@arcadiapublishing.com
For Customer Service and Orders:
Toll Free 1-888-313-2665

Visit us on the Internet at www.arcadiapublishing.com